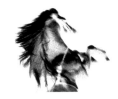

Portrait of the Horse

Sebastian McBride

Published by

Blue Steel Images

Penlan, Rhos-y-garth, Llanilar
Aberystwyth, Ceredigion, SY234SD, UK.

Content Copyright © Sebastian McBride
Images Copyright © Sebastian McBride
www.sebastianmcbride.com

A CIP record of this book is available from the British Library.

First Printed June 2006.

ISBN: 0-9553135-0-3
ISBN: 978-0-9553135-0-9

PORTRAIT OF THE HORSE

SEBASTIAN MCBRIDE

Introduction

This book documents photographically the horse in some of the circumstances that we find it. How an animal species is perceived is affected by one's own exposure and interaction with it, how other people perceive and relate to it but also, exposure to the legacy that the animal has created for itself over the ages. People are rightly or wrongly intrigued by the horse. I am intrigued by the horse but am unsure why. In fact I think I'm not intrigued by the horse but rather attracted to idea of the horse or other people's attraction to it.

This is the first in a series of books documenting the horse in the situations and environments that it finds itself in, determined largely by what people are doing with the horse, how it is being kept and, thus, how it is perceived. It is, therefore, a subjective and biased amalgam of my own intrigue (or not), that is heavily influenced (because I have photographed other people's horses) by other people's function, perception and use of this rather splendid animal. In addition, because the horse is innately aesthetic to the human eye (and perhaps this explains a little of its intrigue), this book also attempts to capture elements of that appeal.

Alcyone's eye (France)

This horse was kept in rather old stables with very limited visual access to other horses. The photograph was taken through the small barred gap through which neighbouring horses could interact. The horse peers inquisitively at the photographer to create the image but there is a quality of sadness in the eye which, through the vertical bars, evokes thoughts of imprisonment and the unnaturalness perhaps of the stabled environment.

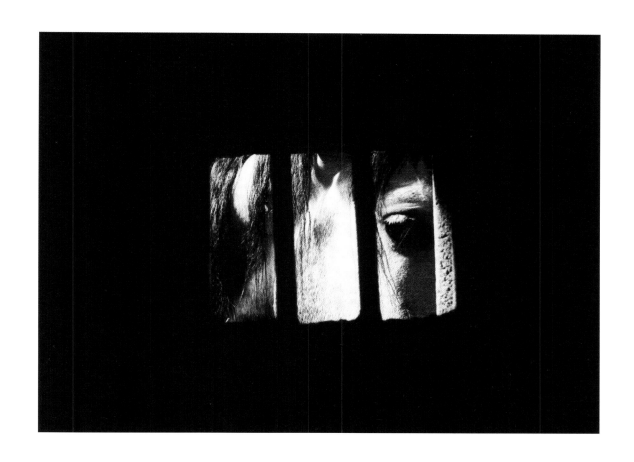

Alcyone (France)

Here we see the same horse but on side profile sniffing through the barred gap with its eyes closed. The natural darkness of the stable with the small skylight above illuminating only the horse's head gives a haunting effect.

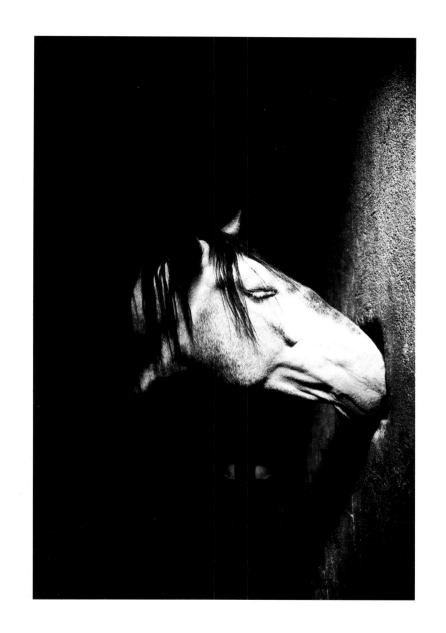

Jota with farrier (France)

Horses are remarkably tolerant given their physical potential. This horse waits patiently until it is shod.

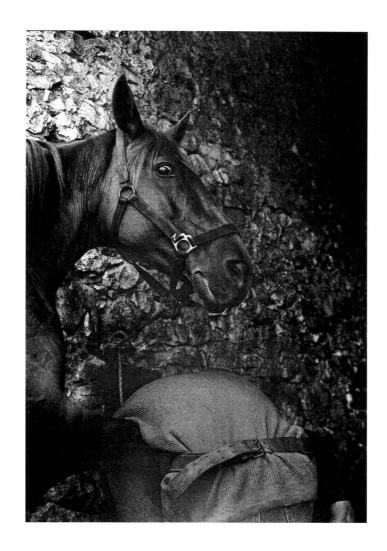

Juno (France)

Lusitano stallion waiting to be shod.

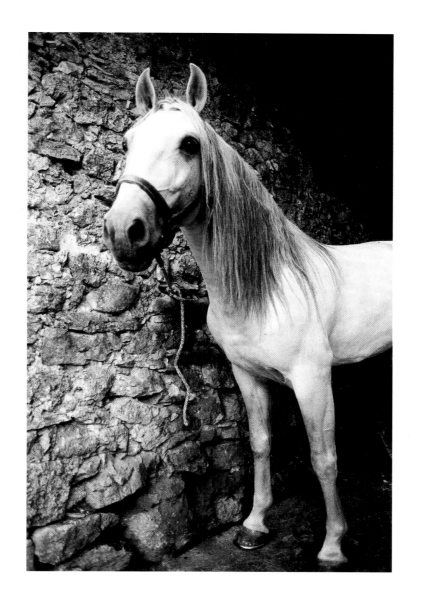

Louis (France)

Lusitano stallion waiting to be shod.

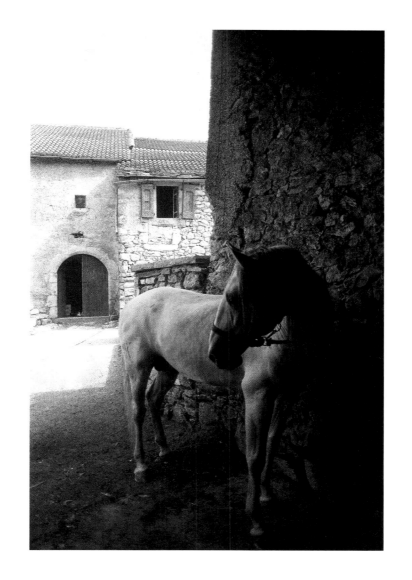

Opus with farrier (France)

Lusitano mare being shod.

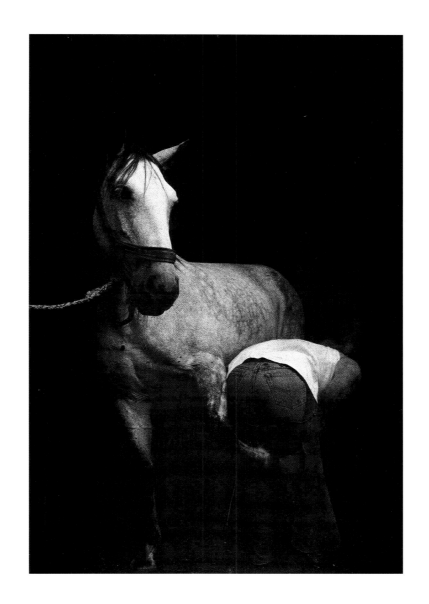

Honrado (France)

A large proportion of a horse's facial expression is through its ears. The ears facing forward and upright in this picture suggests an attentive and focused horse with no aggressive intent.

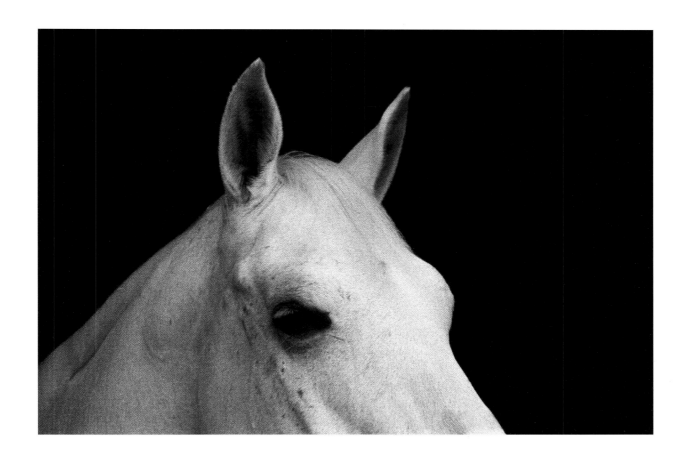

Dansante (France)

Lusitano stallion resting in the stable.

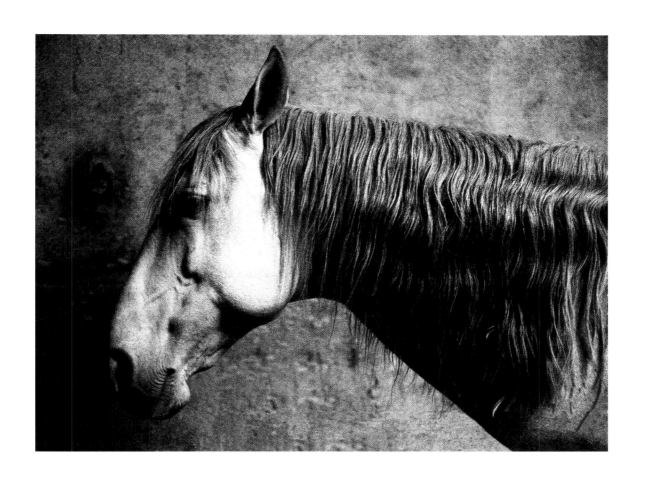

Working in the indoor school (France)

A husband and wife from Montpelier had come to buy this Lusitano mare. The horse had just been ridden (without a saddle) to show its paces.

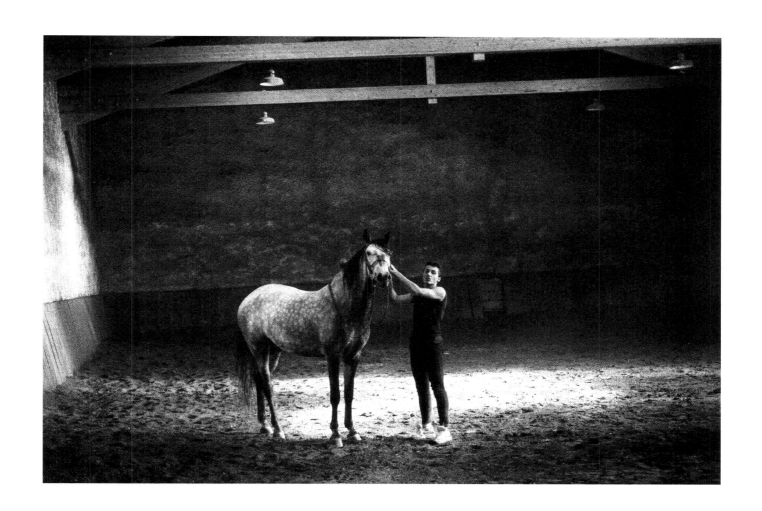

Down by the river (Ireland)

Piebald cobs are very popular in certain fraternities and for that reason good examples of this type of horse are highly sought after. This photograph was taken in Ireland at a horse fair.

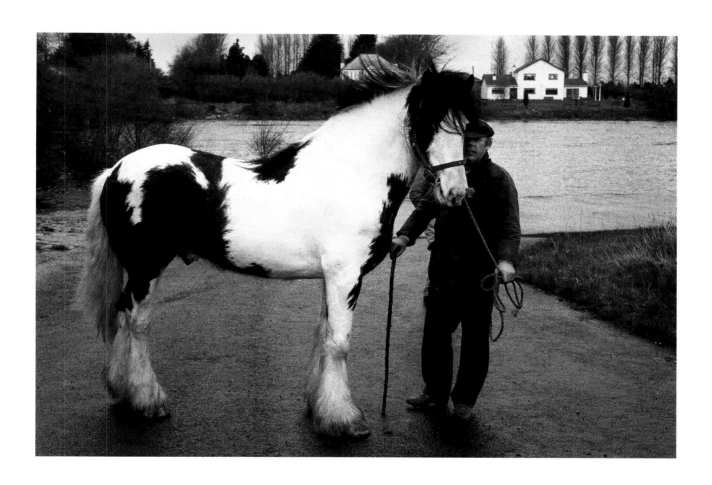

River Horses (Ireland)

This image depicts the intricate art of washing down a group of horses. One lead horse was taken 50 metres up stream and, due to the gregarious nature of the species, all the other horses followed. These horses were about to be sold at a horse fair.

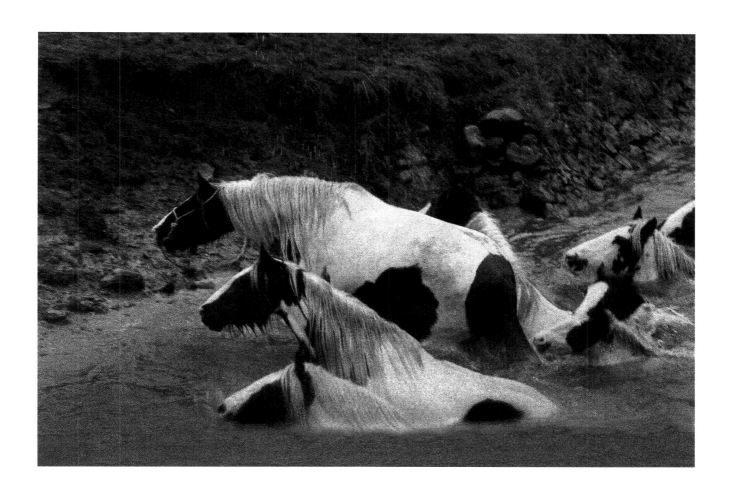

Horse for sale (Ireland)

Knowing the age of the horse is important information before you buy it. Horses without papers or passports can only be aged by looking at the dental patterns on the front teeth. Thus the expression, 'Never look a gift horse in the mouth'.

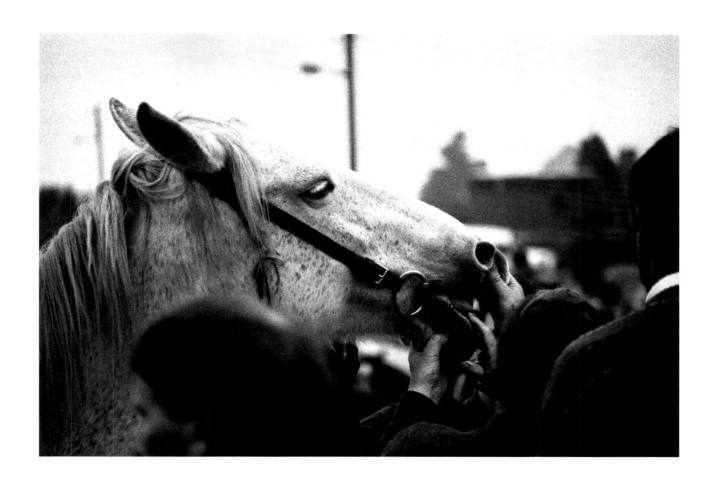

Horse and owner (Ireland)

Cut lengths of alkathene pipe are often seen at animal marts to guide and persuade animals as they off load from lorries, are moved in to holding pens and taken through to selling rings. They are rarely seen in the context of horses because they are perceived more as 'companion' rather than an 'agricultural' animals. In some instances, however, this isn't the case, and the pipe in this picture probably says a lot about how this owner perceives the animal he is holding. The horse in this photograph was startled by someone passing from behind.

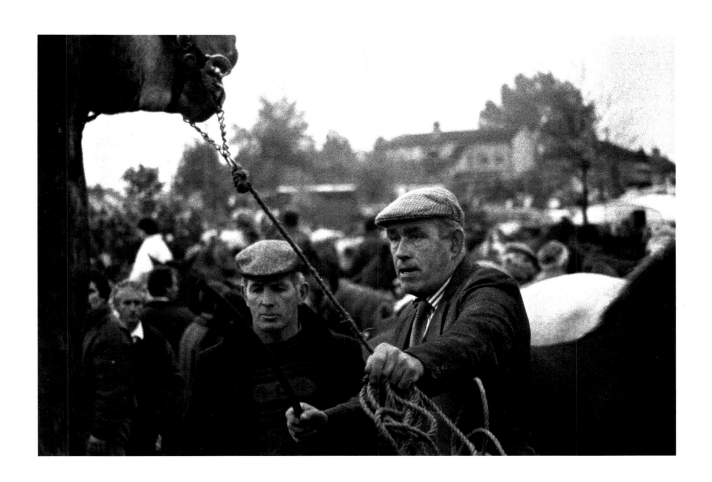

On the common (UK)

Common land in Oxfordshire used for cattle, sheep and horses. This horse rests on a hot summer's day.

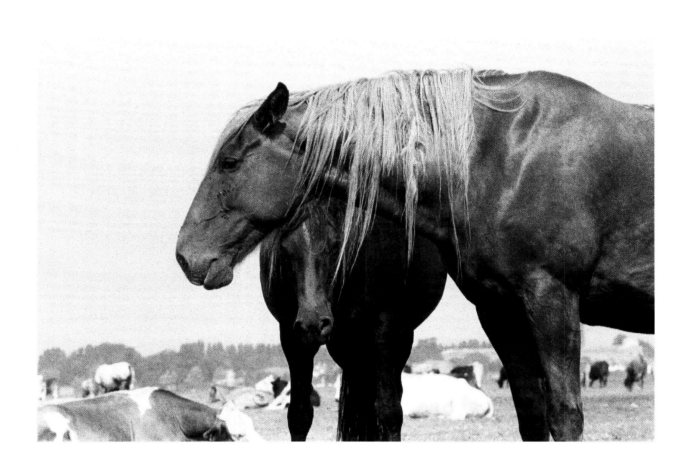

Going for water (UK)

Horses often bond in pairs. These two appeared to be heading for water.

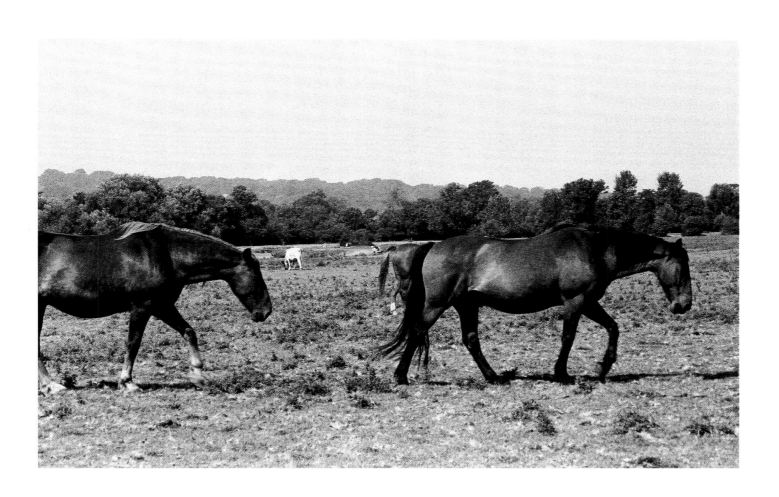

Guarded whilst sleeping (UK)

Horses have evolved to do most of their resting standing up; this gives them the best chances of avoiding potential predators. This horse obviously felt reassured enough by the surrounding company to sleep lying down.

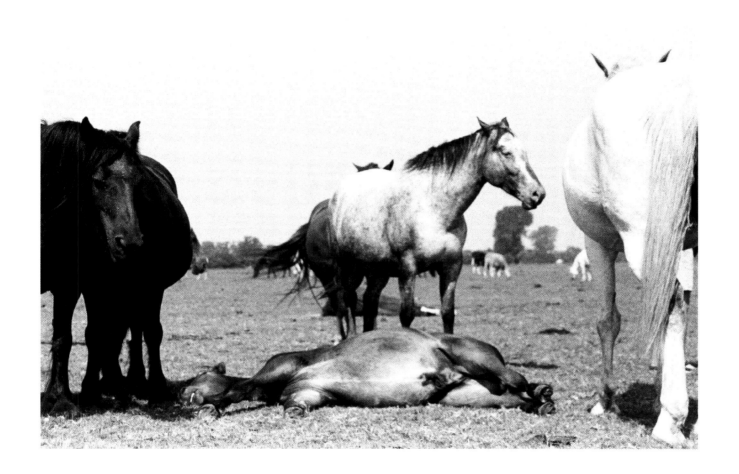

Circus horse working (Switzerland)

The horse was part of a touring Swiss circus performing the archetypal rearing on hind legs with the trainer's whip held high.

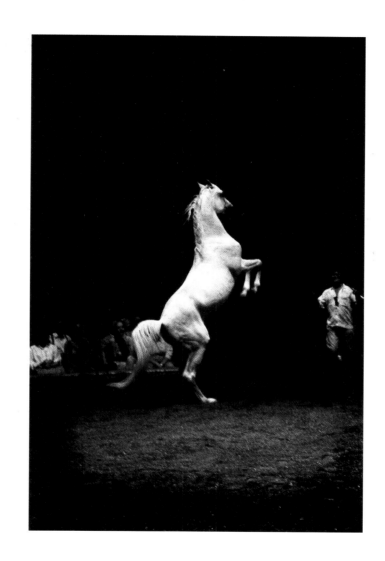

Circus stallions waiting (Switzerland)

Fifteen stallions snorted, squealed and pawed the ground waiting for the trainer to enter the ring.

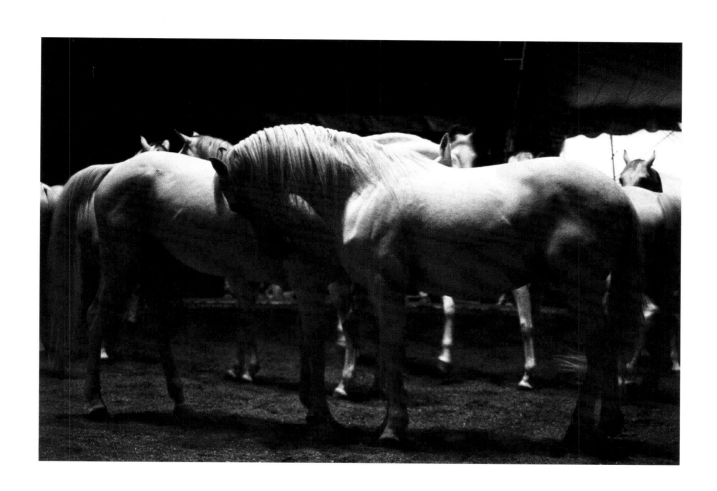

Equus (Switzerland)

The abstracted image of this rearing horse produces a very generic image that epitomises the equine form.

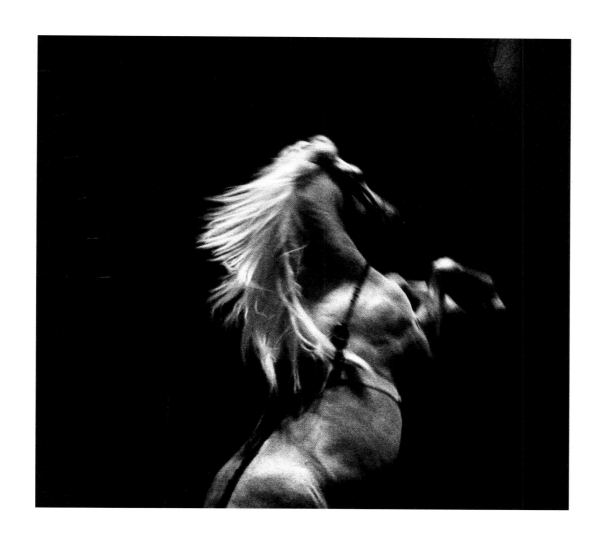

Alto with farrier (France)

Without cue, both horse and farrier turned and looked at the camera.

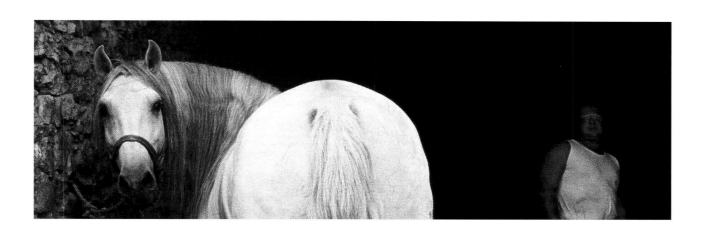

Fasian (France)

The chains, like the bars in Alcyone's eye, give the impression of imprisonment. This arrangement was set up in a forge to simply allow the farrier easy access to all four feet whist keeping the horse in one place.

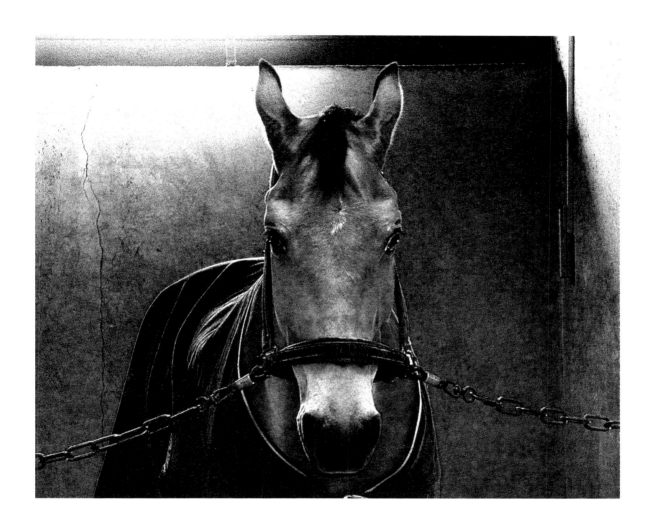

Minty (UK)

Modern stables facilitate the greatest amount of visual, olfac-
tory and tactile stimuli between horses through extensive
grill-type systems. Unfortunately, Minty was too small to reap
the benefit of this design.

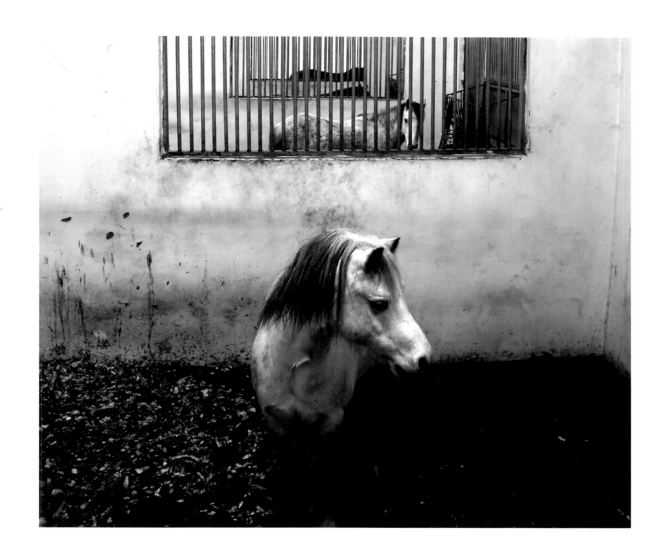

Horses at night (UK)

A friendly interaction by moonlight.

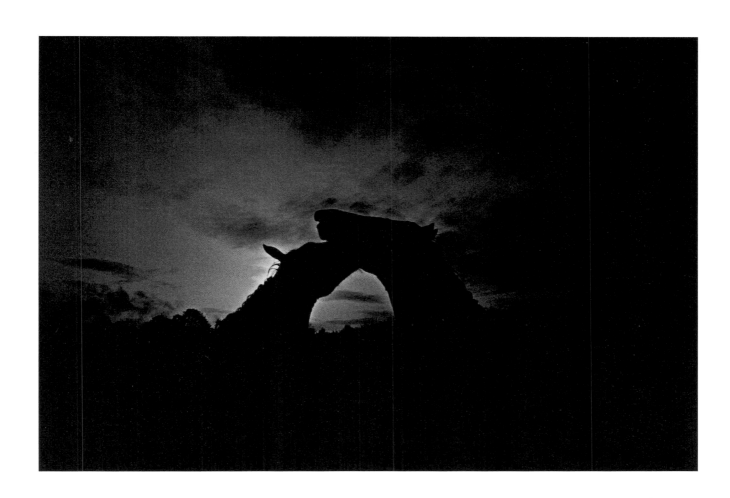

Artemis (France)

Stabled Lusitano stallion.

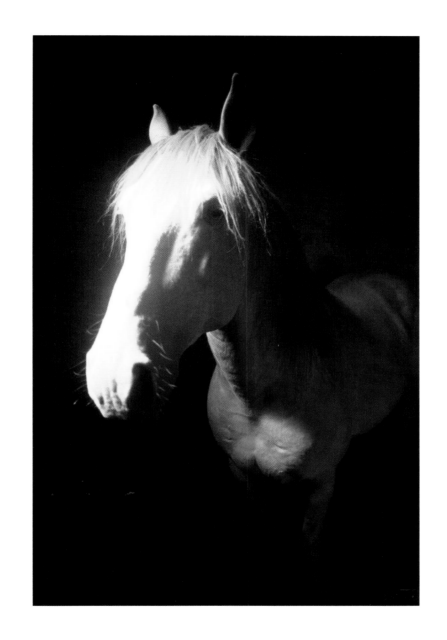

Balthius (France)

Stabled Lusitano stallion.

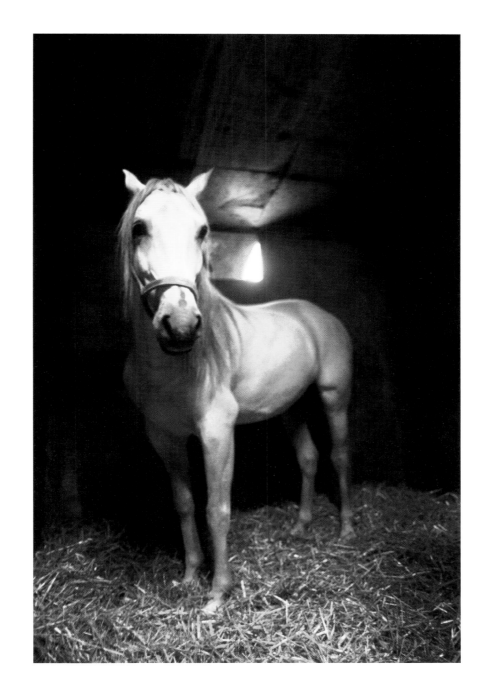

Eclipse (France)

Lusitano stallion held at stud.

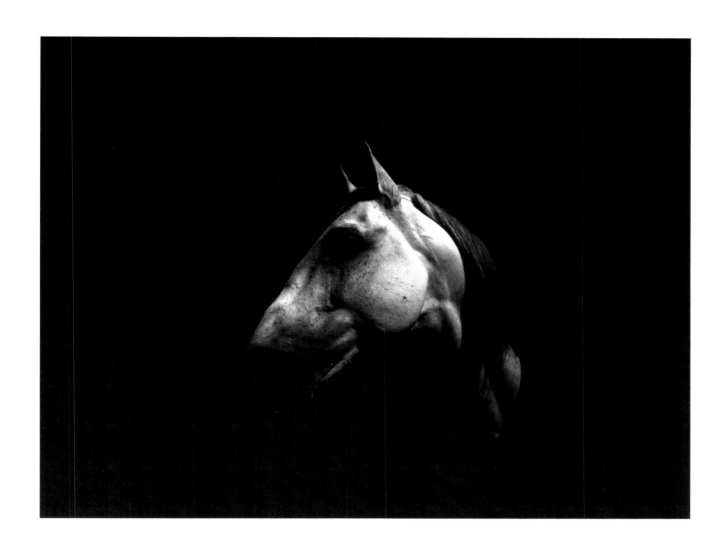

Hercule (France)

Percheron stallion held at stud.

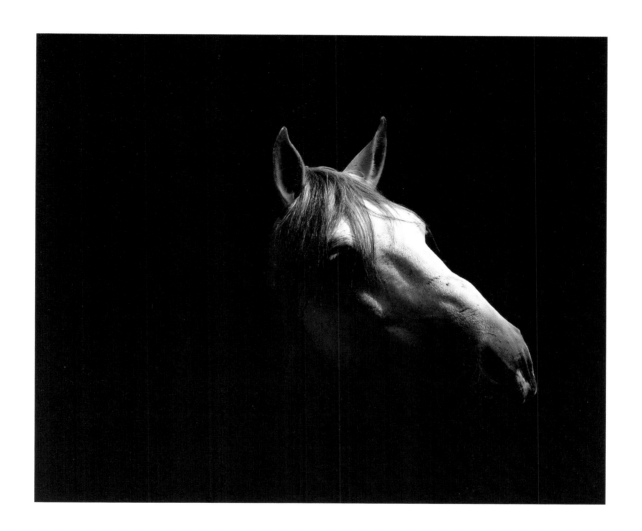

Vaccares (France)

Arab stallion held at stud.

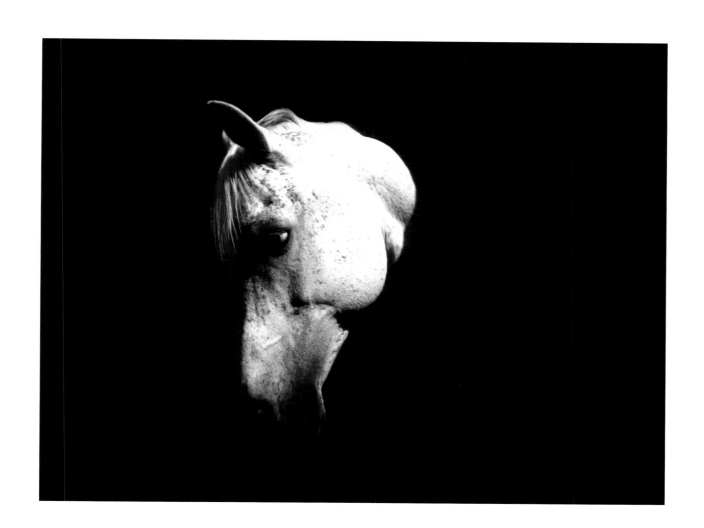

Unknown (UK)

Horse abattoirs in the UK are not plentiful but do exist, producing horse meat to go abroad. Much of the unused carcass is procured by veterinary, animal and equine science colleges for use in practical dissections. This photograph was taken just prior to a dissection class.

Causse du Larzac (France)

The Causse du Larzac is a huge expanse of open plateau running between the gorges of Aveyron in southern France. This camargue horse was being rounded up for a day's trekking.

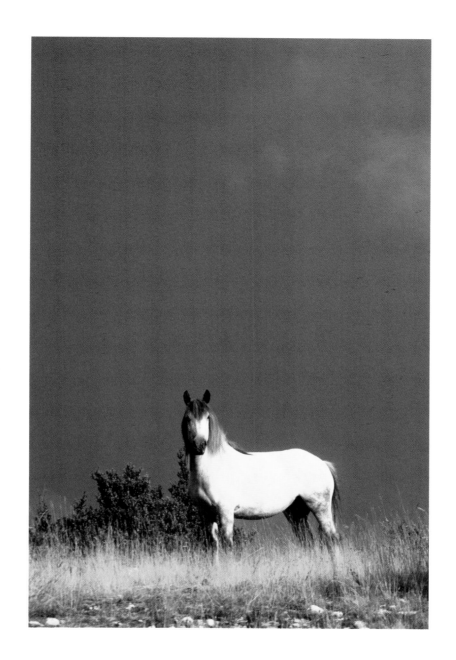

Lusitano Moon (France)

Dismounted on an evening hack.

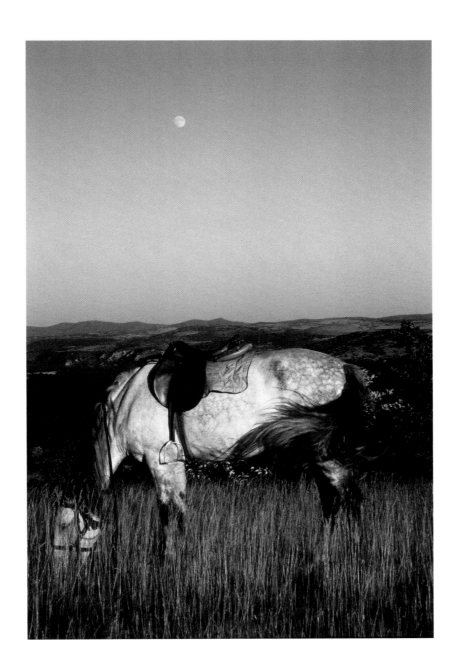

Horse sold (Ireland)

The horse had just been sold at a fair in Ireland. Onlookers observe the exchange between vendor and buyer.

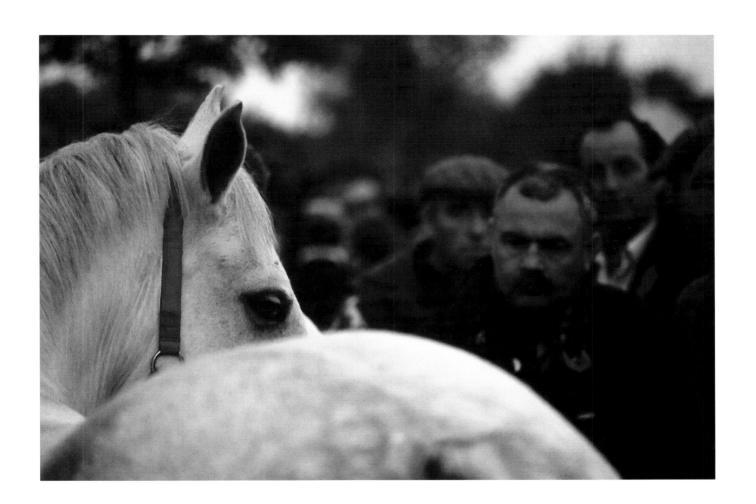

Trotter (Ireland)

Side roads at horse fairs are often taken over and trotting hors-
es put through their paces to attract a sale. The roads are never
very long and this horse is being quickly pulled to a stop to
avoid collision. There is obvious distress on this horse's face.

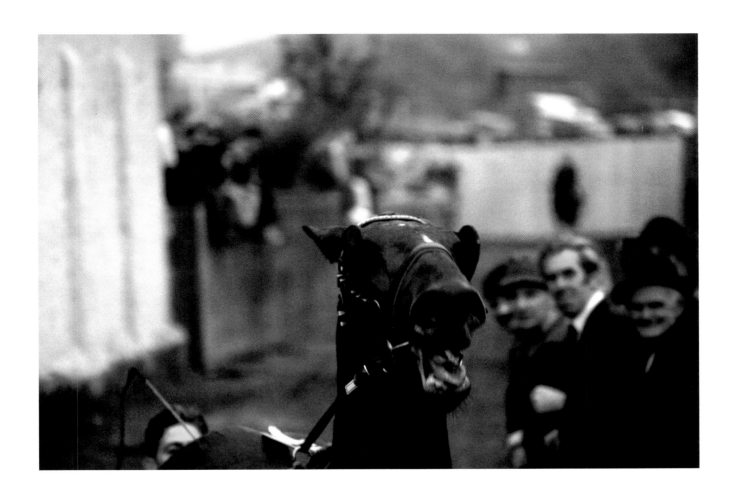

The morning swim (UK)

Swimming is considered by some race horse trainers to be beneficial to the training programme. The horse swims round in a circle with one man leading from the middle and the other walking the outside.

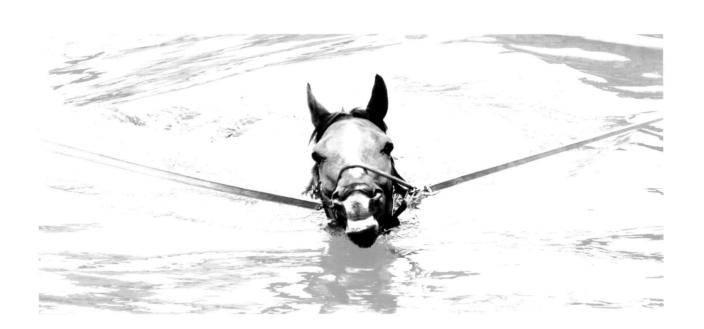

Welsh Section A (UK)

This Welsh Section A pony had just won first place at a local
show. The hessian backdrop gives added definition to the
pony's winning outline.

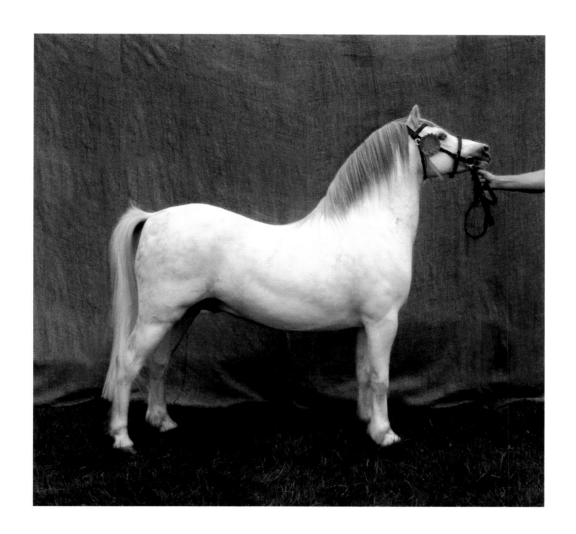

Sacred Horse (Japan)

The sacred horse 'Kotuku' occupied the sacred stable in a shrine just north of Tokyo; he was a gift from New Zealand to Japan. The name means 'bright virtue' in Japanese and 'rare and sacred visitor' in Maori.

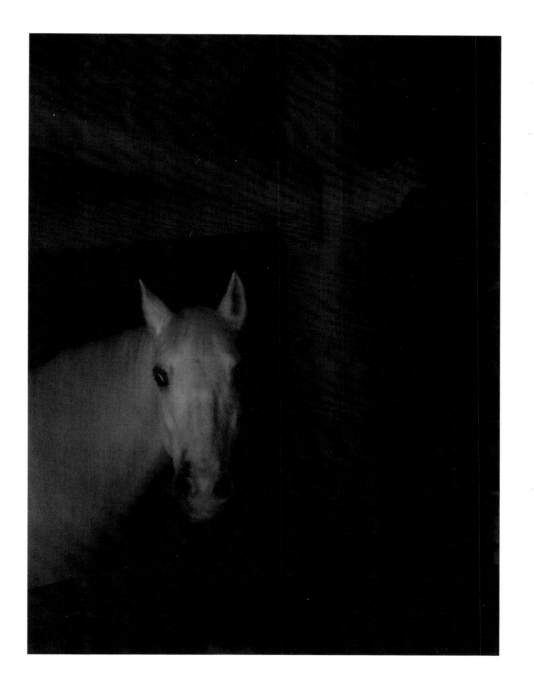

Chateau Horse

These 18th century French stables just north of Paris are considered to be the most grand in the world.

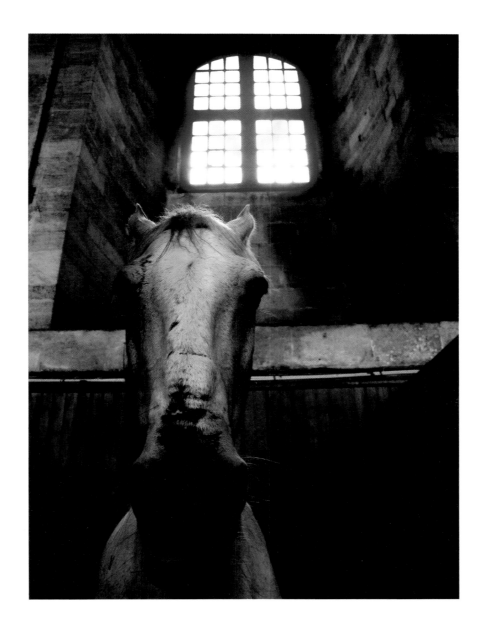